# ROUGH

## DRAWING IN 2 STROKES AND 3 MOVES

**ROUGH** DRAWING IN 2 STROKES AND 3 MOVES
Pierre Pochet

Project editor: Maggie Yates
Project manager: Lisa Brazieal
Marketing coordinator: Katie Walker
Copyeditor: Maggie Yates
Graphic Design and Layout: Graphében
Layout production: WolfsonDesign
Cover production: WolfsonDesign

ISBN: 978-1-68198-895-5
1st Edition (1st printing, August 2022)

Original French title: Rough : le dessin en 2 traits 3 mouvements
© 2015, 2020 Éditions Eyrolles, Paris, France

Translation Copyright © 2022 Rocky Nook, Inc.
All illustrations are by the author

Rocky Nook Inc.
1010 B Street, Suite 350
San Rafael, CA 94901
USA
www.rockynook.com

Distributed in the UK and Europe by Publishers Group UK
Distributed in the U.S. and all other territories by Ingram Publisher Services

Library of Congress Control Number: 2022932064

Pierre Pochet

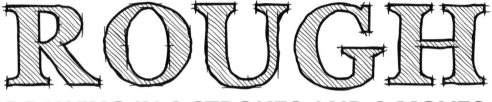

# ROUGH
## DRAWING IN 2 STROKES AND 3 MOVES

## People, Animals, Scenery, Objects...

rockynook

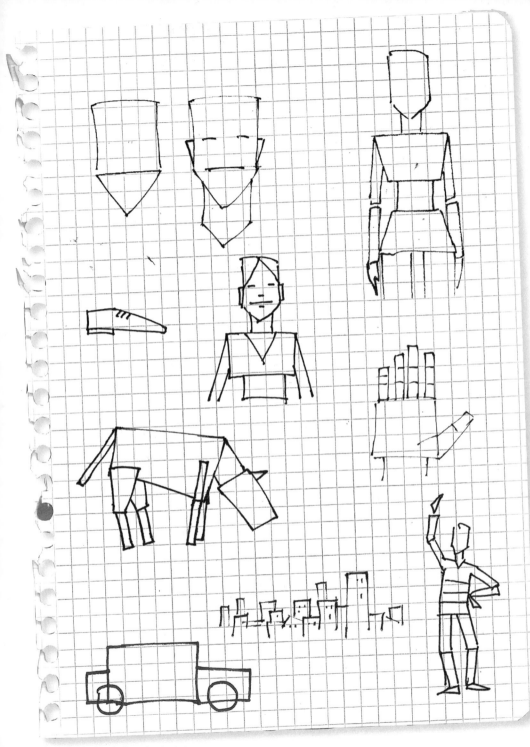

Initial sketches before the final drawing,
sketched in a simple notebook.

# Introduction

Do you know how to draw a line? A square, a rectangle, a triangle?

Well then, congratulations! You know how to draw!

What you have in your hands is my first book. Thank you for that. This volume is the result of 30 years of adventures as an artistic director in the advertising world.

In my 30-year career, I have had to work on thousands of projects—some of them good, some of them less so; some of them thrilling and some of them ho-hum. It was a long journey that allowed me to develop my own drawing technique over time. There is nothing academic about it, but it allows me to meet the demands of my business: quickly getting ideas down on paper.

I don't have the knowledge, nor do I claim to, to offer you a class in anatomy, architecture, and design all at the same time. And yet the technique that I am going to suggest ought to be able to quickly allow you to draw a face, an expression, an attitude, a car, a scene…

It will also allow you to understand the staging of a scene, a perspective, a framing, and a point of view in a given format.

This technique is based on putting together simple, easy-to-draw geometric shapes.

The examples you will find in this volume will, I hope, allow you to create your own models very quickly and use them in your daily work.

But at first, please don't skip ahead. The mistake that a lot of beginners make is to want to make a "beautiful drawing" right away, but in order to make a beautiful drawing, you first have to lay the foundations.

Don't be impatient. Take the time to look, to observe, to draw.

It took me a year to put this book together. That may be how long it takes you to master creating roughs!

Have fun!

**Pierre Pochet**

# Rough: A Definition

A "rough layout" is a drawing technique that is used in publishing, film, advertising, and other artistic fields.

It is a relatively succinct drawing that allows an artist or a designer to quickly create a scene with one or more characters, a setting, a landscape, some objects…and to present an overview of an idea, a scenario, or a layout of texts and images.

This prototype is a simple outline, in black felt marker, of the character or characters, staged in their environment.

The format may vary from a regular 8 1/2 x 11-inch page down to a quarter of that size, 4 1/4 x 5 1/2 inches, depending on the complexity of the drawing and the number of elements that need to be included.

While it is not a final product, this drawing technique requires an analytical understanding and an ability to grasp the big picture. The result will not be reproduced nor published but it will be used as the basis for creating a model that is in color and closer to the final product, called a "push layout," or for creating the final photograph or illustration. It is also, and above all, a basis for discussion and a foundation for the dialogue between the artists and their clients.

Some examples of roughs: storyboard for a TV commercial; layout for a poster project; introduction of characters…

# Tools and Techniques

## Markers

Specialized stationery stores stock a very wide choice of markers, from very fine to very thick and from very hard to very soft. Chisel-tip and brush-tip markers require a certain level of dexterity, so they are best avoided if you are a beginner.

The choice of width will depend on the size of your rough and the effect you want to achieve. To start with, I suggest choosing two kinds of marker that are easy to use.

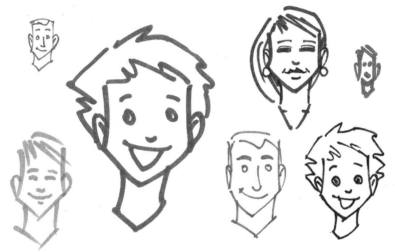

A few examples of renderings showing different thicknesses of marker.

The **Pentel Stylo JM20** (on the left) or the **Tradio TRJ50** (on the right): fine markers whose pen points allow for solid or looser lines.

**Pentel Sign Pen**: a thicker marker for shading, lettering, or filling certain areas.

## Paper

Your preliminary sketches can be made on plain white photocopy paper. When creating your final drafts, however, I suggest that you use marker paper, sold in specialized stationery stores and intended for the creation of rough layouts. This

semi-transparent paper lets you copy a drawing without having to use a light table. It is specially designed for coloring with a marker.

# Drawing Format

The three formats I am going to suggest that you work in use the proportions of the most common paper and audiovisual media.

The first two (vertical and horizontal) have the proportions of an 8 1/2 x 11 page and roughly correspond to the standards of the press and the film industry.

The third format, which is longer, allows you to familiarize yourself with certain kinds of urban display or Internet banners.

Whatever size and shape you are going to be making your drawing in, get into the habit of sketching the format onto your page freehand, without measuring it, in order to memorize its proportions. This will save you time and energy.

It will also allow you to define the area in which you are going to draw and the boundaries within which you need to build your scene.

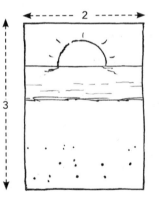

Vertical framing, also called "French format." The numbers indicate the format's proportions.

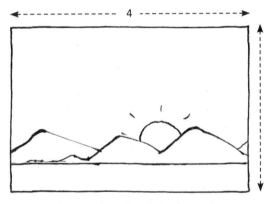

Horizontal framing, also called "Italian format." The numbers indicate the format's proportions.

Panoramic framing. The numbers indicate the format's proportions.

# Techniques

At first, of course, you will have to search, test, try things out…Your first sketches will probably be flawed and you will have to make a number of corrections in order to achieve just the right expression, attitude, or movement…Try these two techniques and see which one of them works better for you.

**1.** Make your initial sketches and corrections in pencil on the marker paper. Make your final drawing in marker on the same piece of paper. Then erase the pencil drawing.

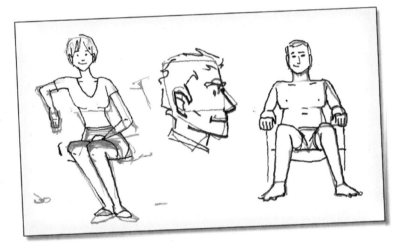

**2.** Make your sketches and corrections in marker on a piece of photocopy paper. Then trace them onto the marker paper to make your final drawing.

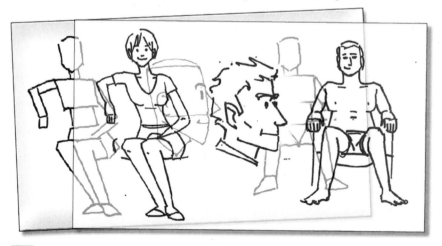

## Framing

In photography, framing consists of choosing the borders of your visual field in order to achieve a harmonious distribution of the elements of your picture. The same is true for a drawing.

Think about the character that you want to draw: Do you want to draw attention to a detail of the person's clothing, their expression, or their stance? What part of the page will the drawing take up? Where are you going to start?

The mistake that most beginners make is to start with the details. Then they let themselves be guided by the start they have made, without knowing where it will end up. Think about the frame, then, before you start your initial sketching.

Of the most commonly used frames in photography and film, the extreme close-up and the close-up emphasize a person's emotion, expression, and character. The facial frame and the three-quarters (or medium) frame allow you to introduce the person, their gestures, and the environment they are in.

The farther away the person is, the more attention will be given to the environment in which the action takes place and the atmosphere that arises from it.

These kinds of frames can either elicit an aesthetic emotion or suggest the person's isolation.

 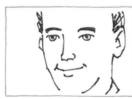  

Extreme close-up.

Close-up.

Facial frame.

Three-quarters frame or medium frame.

Whole-body frame.

Wide frame.

## Rendering It in Color

While the techniques suggested here will allow you to get ideas and projects down on paper, most of the time the sketch is then colored in before it is presented to the client.

This coloring is done with markers that are specially designed to be used on marker paper. The various brands that you will find in specialized stationery stores (such as Ad Marker, Copic, Tria) offer a wide range of nuances in all the colors of the rainbow.

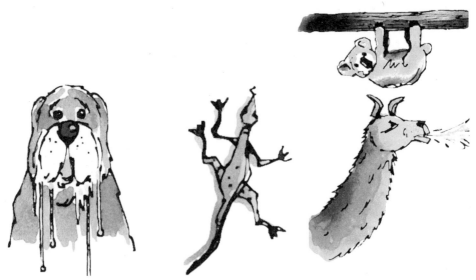

Illustration project for a research laboratory.

Animated spot proposal for a department store chain.

Material for a store selling
musical instruments.

Proposal of visuals for car commercials.

## Lettering

Most projects that you will be asked to carry out will include text. This text will also influence your framing, based on its length and the importance that you want to give to it in your layout.

There are thousands of typefaces available, and covering them all would require many volumes, but if you follow these few pieces of advice, you will quite quickly be able to learn how to draw basic lettering in a consistent fashion and to choose the appropriate thickness for it.

**1.** Start by drawing two parallel lines in pencil, and then drawing in the alphabet between them, using a marker.

abcdefghijklmnopqrstuvwxyz

abcdefghijklmnopqr

abcdefghijklmnop

abcdefghijklmno

**2.** Repeat this exercise several times, putting the parallel pencil lines farther apart and closer together and experimenting with different marker thicknesses.

**3.** With a little bit of practice, you will be able to do lettering that is large or small, fine or thick, and to determine the size and the impact of the text within the page layout.

Hello. How are you? Goodbye!

Happy Anniversary.

HELLO! GOODBYE!

WELCOME TO THE CLUB     WELCOME TO THE CLUB     WELCOME TO THE CLUB

1,2,3.....2..1.! 25

 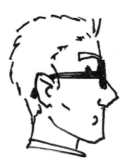 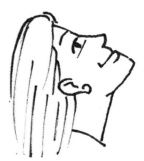

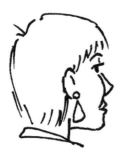 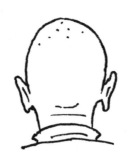 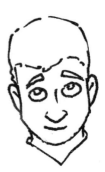

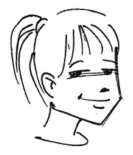 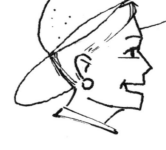 

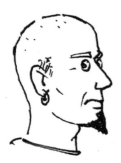  

# The Face

## Getting Started

The face can be built out of a square and a triangle. The forehead takes up approximately the upper third of the face. The middle third is made up of the eyes, the nose, and the ears. The bottom third goes from the base of the nose to the tip of the chin.

Lowering the line of the eyes and the line of the base of the nose increases the surface area of the forehead and diminishes the length of the nose. This process, which is similar to caricaturing techniques, lets you produce a more feminine-looking face. And if you accentuate the process further, you get an increasingly childlike look.

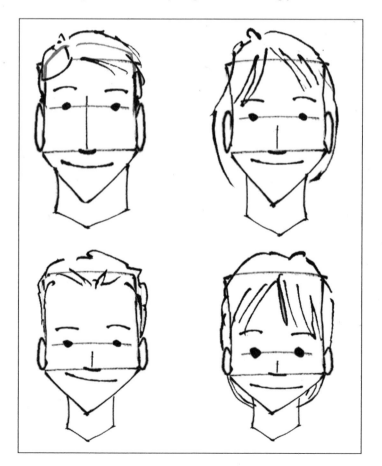

**1.** First, draw the rough outline of the faces: draw four squares and, underneath each square, a triangle. For a man's face, the triangle should be half as tall as the square. For a woman's or child's face, reduce the height of the triangle.

**2.** Draw a fine horizontal line at the midpoint of the first square, for the man's face. For the others, draw it farther and farther down.

**3.** Draw a fine vertical line in the center of each of the squares (as shown).

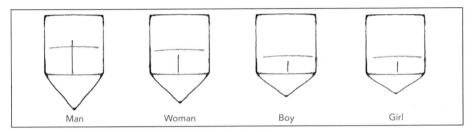

| Man | Woman | Boy | Girl |

**4.** Draw the pupils of the eyes, each centered between the vertical line and the respective edge of the square.

**5.** Draw the base of the nose along the bottom edge of the square and, underneath that, the mouth.

**6.** Draw the ears in the (vertical) space between the eyes and the base of the nose.

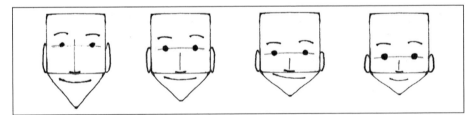

**7.** Round off the top of the head.

**8.** Draw the neck. For a man, draw it as an extension of the face. For a woman, draw a narrower neck, and for the children, make it even narrower still.

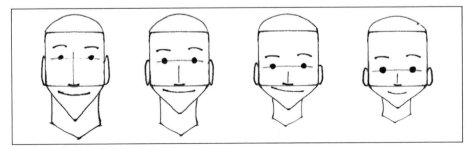

# The Face in Motion

Just as with frontal drawings of the face, the square and the triangle will form the basis of all the movements.

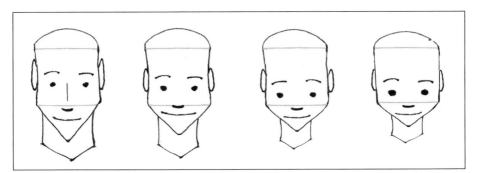

For a downward gaze, move the eyes, nose, and mouth downward and the ears upward.

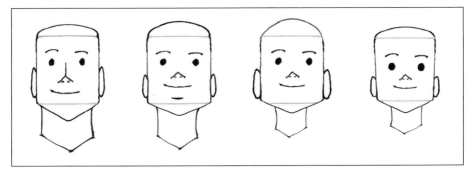

For an upward gaze, invert the process: the eyes, nose, and mouth move upward and the ears move downward. The nose turns into a little triangle to indicate the view from below.

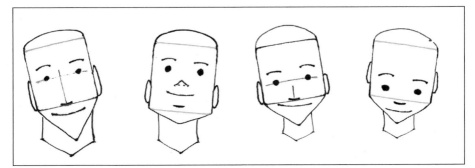

The face is rarely fixed or static. By tilting it lightly to the left or the right, you will give it a little more life.

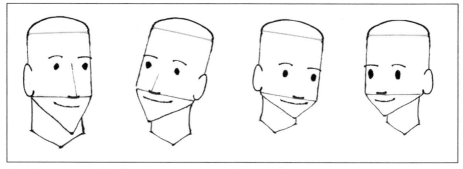

For a view from the side, offset the triangle to the left or the right. Move the nose, eyes, eyebrows, and mouth in the same direction. Enlarge the ear that is visible. The neck should be moved in the opposite direction from the triangle of the face.

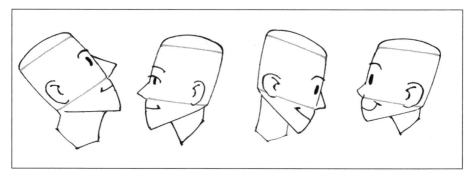

For a face seen in profile, the square becomes a parallelogram offset either to the right or to the left. The nose becomes a triangle, longer or shorter depending on gender and age. The ear becomes rounder. The neck becomes thinner or moves farther back.

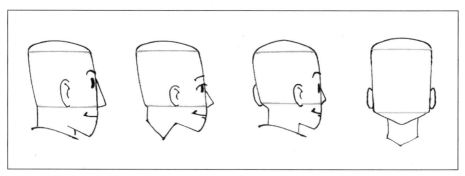

In a three-quarter rear view, the skull takes on greater importance. The more the view moves toward the back of the character, the closer the eye and mouth get to the edge of the square and the less visible the nose becomes.

# Refinements

The addition of a few well-chosen details can allow you to refine the characteristics of gender and age: cheeks, hair, nose, mouth, ears…

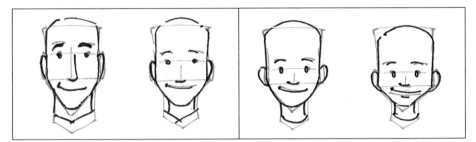

After having sketched the basic elements of the face (shown here in gray), you can now round out the cheeks and the base of the chin (shown here in black) in order to make the face more realistic.

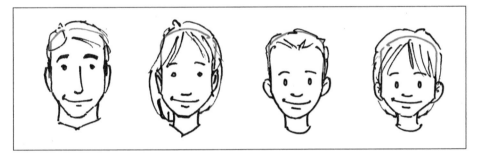

To give the character a hairstyle, draw a few somewhat messy lines above the skull, around the temples, on the forehead, and under the ears…Keep in mind that typically, a man or a little boy will have shorter hair than a woman or little girl.

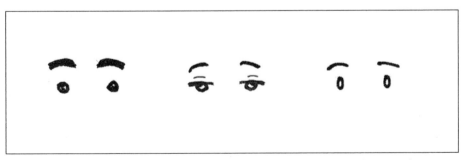

To emphasize the masculinity of the eyes, thicken the eyebrows. In order to make them more feminine, add a little line to indicate the eyelashes and another one below that to indicate the eyelid.

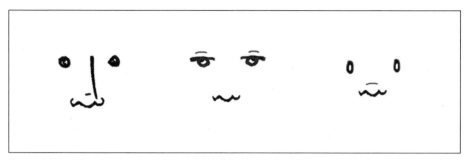

A wavy line stands in for the tip of the nose and the edge of the nostrils. In order to make the nose more masculine, draw in the bridge of the nose as well.

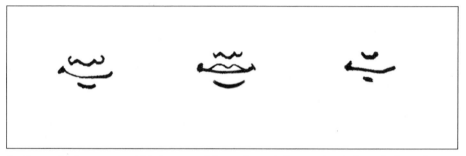

For the mouth of a man or a child, draw a small line underneath the mouth to indicate the lower lip. For a woman, add a wavy line above the mouth to make it fuller.

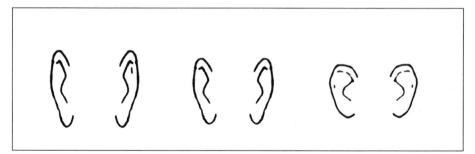

For the ears, draw an oval and then a small oblique line to create some depth. Draw smaller, more delicate ears for a woman and make them rounder and more prominent to make them more childlike.

# Differences in Shape

What kind of character do you want to draw? A child, a teen, a woman, an old man…? And if it's a child, is it a little girl or a little boy? Is he or she earnest, goofy, does he or she wear glasses or have dimples? Does your teenager have acne and messy hair, is he or she grouchy? If it's a woman, is she plain-looking but sexy? Or pretty but stuck-up? If it's an old man, is he still lively, or does he walk with a cane? You have to decide all this before you pick up your pencil.

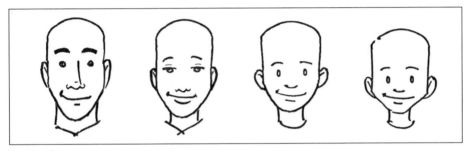

Standard faces.

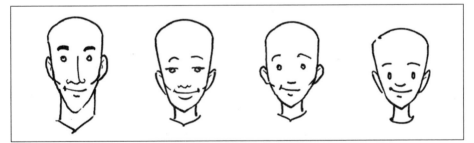

For a thin or lean face, emphasize the triangularity of the face and chin. Draw a small oblique line along the cheeks in order to make the face look bonier.

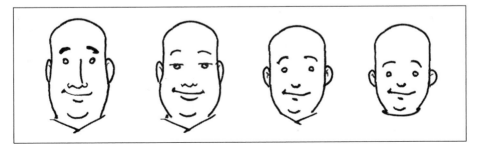

For a round face, make the cheeks and the base of the face wider. The neck and the face form a single mass. The tip of the chin is indicated by a small, rounded stroke.

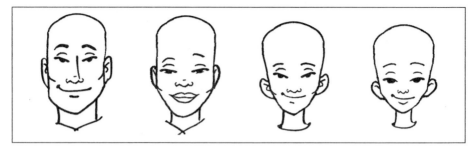

To make a face look Asian, emphasize the shape of the eyelids by lifting them up toward the outside of the face. Use a small diagonal stroke to accentuate the cheekbones.

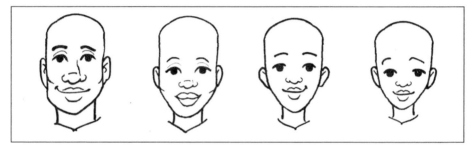

For an African-looking face, the eyes are larger, the nose and nostrils wider, and the mouth more full. Again, use a small diagonal stroke to emphasize the cheekbones.

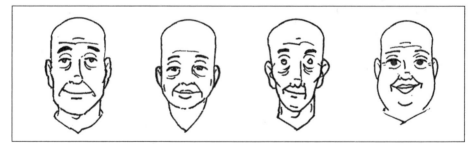

Add wrinkles everywhere—under the eyes, on the forehead, around the mouth, on the chin—and presto, you have some lovely grandparents.

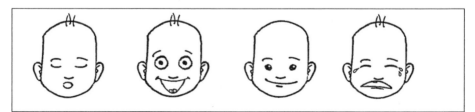

Use a round face, big eyes, and prominent ears...and you have a baby, laughing, sleeping, smiling, crying.

# Hairdos and Accessories

A receding hairline, black curly hair, a few freckles on the chin, a little bow holding up a ponytail, an earring, an escaping lock of hair…these are all little touches that will add character to the people you draw.

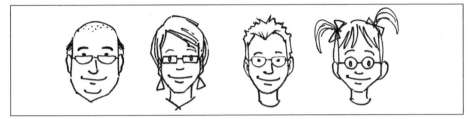

Large or small, round or square, glasses can also help to sharpen the specificity of a character.

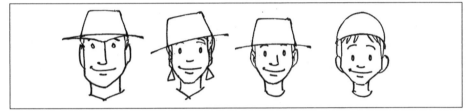

For drawing a hat, the basics are just a long, horizontal line at the height of the eyebrows, and a rectangle on top of that.

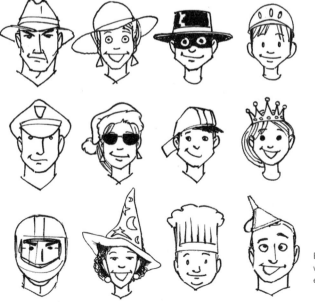

By using different accessories, we can create a multitude of expressive variations.

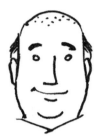 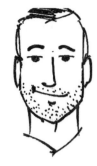 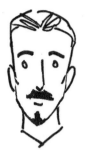 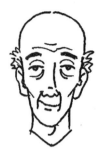

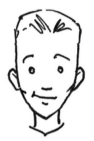 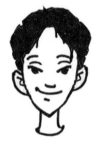 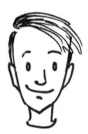 

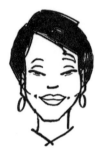 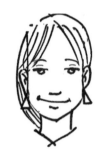 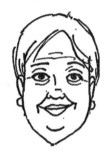 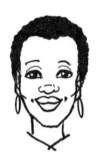

# Expressions

Do you take selfies? Do you send them to your friends? I am willing to bet that, most of the time, your selfies show you making faces. But of course, you are not being silly all the time. Sometimes you are earnest, pensive, surprised...The expression on a character's face is always a reflection of the feeling that the character is giving off: happiness, a good mood, surprise, panic...and whatever the shape of the face or the person's age or gender, the expressions are a result of the combinations of the position of the eyebrows, how wide open the eyes are, and the shape of the mouth.

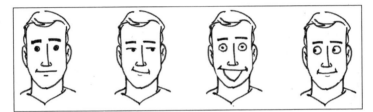

Eyebrows going straight across express friendliness and happiness.

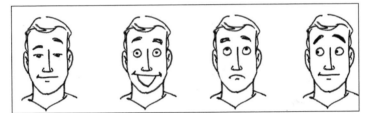

One raised eyebrow expresses skepticism; two raised eyebrows indicate surprise.

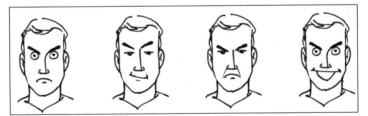

Eyebrows drawn together and down indicate contrariness, meanness, or anger.

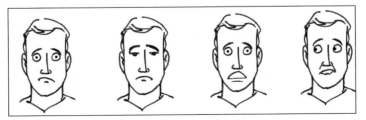

Eyebrows close to the eyes express sadness or fear.

# Details

If your rough is small, the face will be limited to simple lines. But the larger your rough is, the more details you can draw in and the more you can refine the personality.

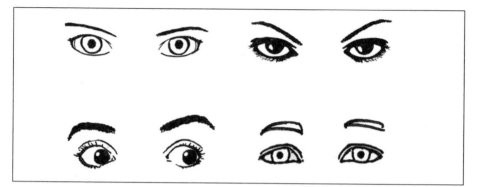

There are as many possible variants as there are different human beings: eyes that are light or dark, makeup that is heavily applied or with a lighter touch, a heavy eyelid…

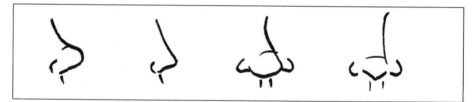

An aquiline nose (in profile, at left) or a flatter one (from the front, on the right)…

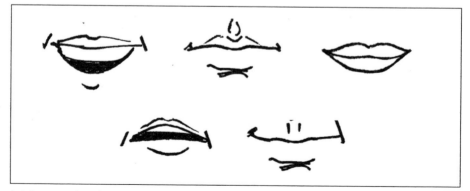

A delicate mouth or full lips, large white teeth…or not!

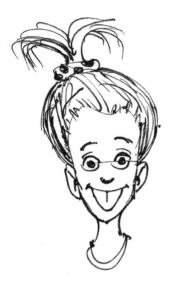
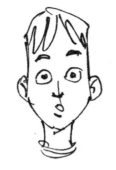
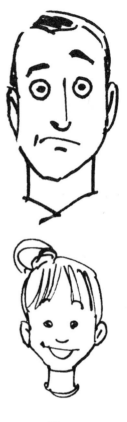
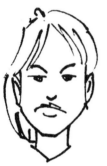
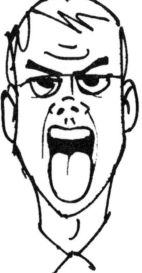
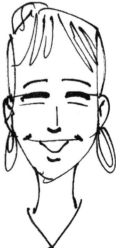
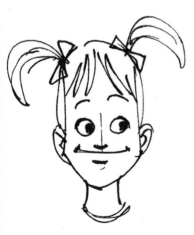
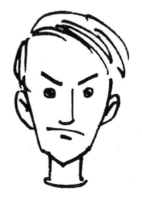

## Sample Figures

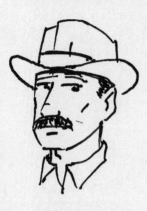

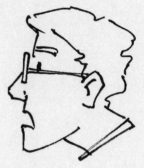
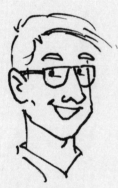
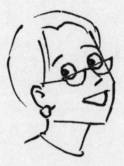
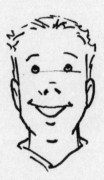

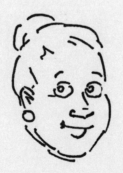
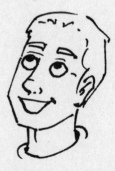

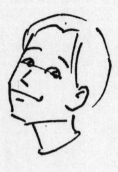
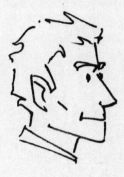
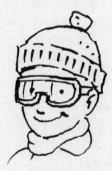

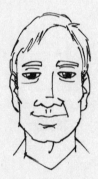
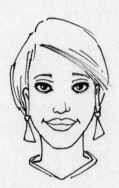
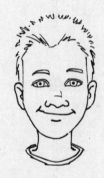

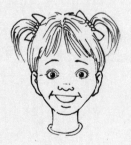

PORTFOLIO

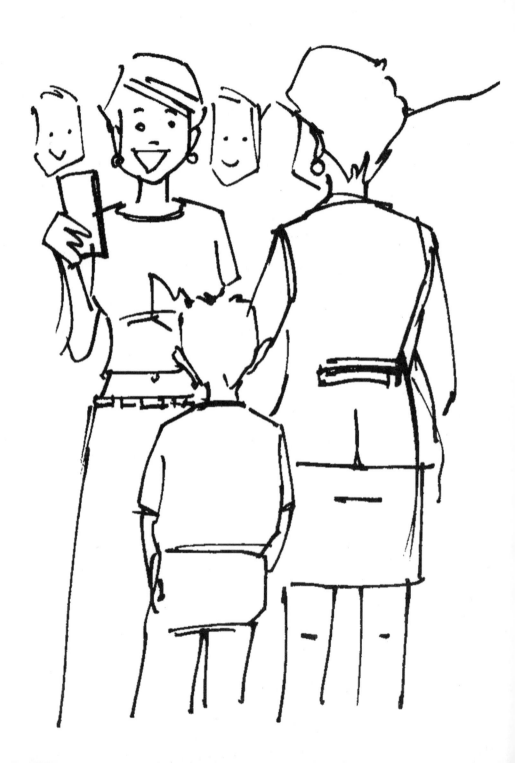

# Busts

## Getting Started

Schematically, the chest, abdomen, and pelvis can be represented as three stacked rectangles. The same is true for the upper arms, the forearms, and the hands. The proportions of these rectangles vary depending on gender and age.

First draw the head and the neck, as we have already discussed, then draw the three rectangles of the torso.

**1.** Draw the first rectangle, which represents the shoulders and the chest. It should be just slightly trapezoidal, and it is wider for a man, narrower for a woman or a child. For a woman, emphasize the trapezoidal aspect.

**2.** Draw the second rectangle, which represents the abdomen. It should be slightly narrower than the first rectangle for the man and the child, and much narrower for the woman.

**3.** Draw the third rectangle, which represents the pelvis. It should have the same width as the first rectangle, and again be more strongly trapezoidal for a woman.

**4.** Draw the rectangles that represent the arms, which will have varying thicknesses depending on gender and age.

**5.** Draw the rectangle for the upper arm and the biceps, which go from the shoulder down to the waist. Draw them a little thicker for a man. The forearm, for its part, runs from the waist to the crotch and is a little thinner than the upper arm.

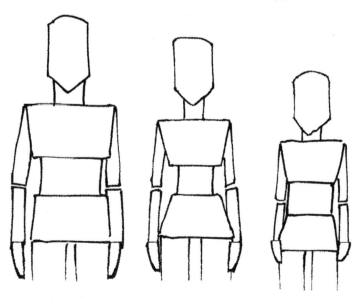

# Differences in Shape

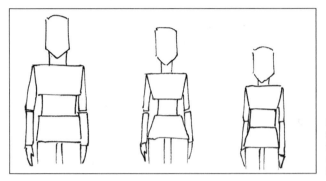

For a standard torso, the three rectangles (for the chest, the abdomen, and the pelvis) are clearly distinguished from each other.

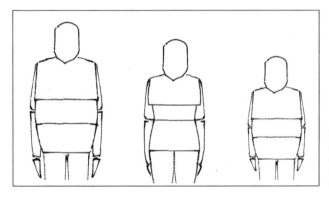

For a round torso of a man, woman, or child, the chest, abdomen, and pelvis become wider and make up one single rounded mass.

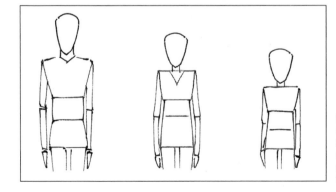

For a thin torso of a man, woman, or child, the chest is narrower and the abdomen and pelvis are less pronounced, practically just extensions of the chest.

# Movements of the Torso

Except for the position of a soldier at attention, the torso is never held in a fixed position. Even when a person is standing still, nothing is really straight or parallel. Everything is in motion: the head, the neck, the shoulders, the waist, the hips, the arms…

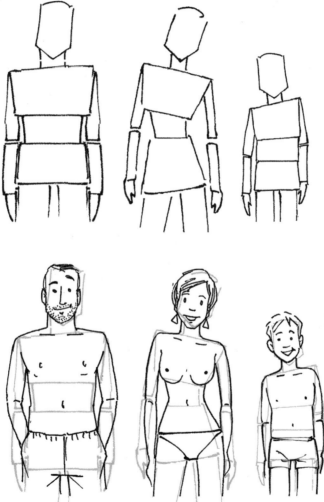

As with the face, once you have drawn the basic elements, round out the upper arms and forearms, the angle of the shoulders, and the chest, waist, and hips. Add a few strokes to represent the collarbones, the bend of the elbows, the belly button…

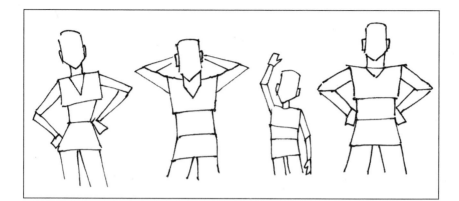

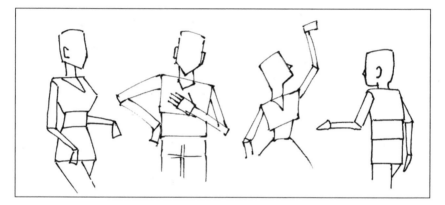

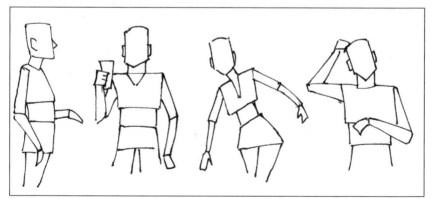

By changing the shape and position of the various geometric forms, you can produce all of the different positions of the body. One small piece of advice: Before drawing any position, take the time to act it out yourself and to observe yourself while doing so. That will then make it easier for you to capture it on paper.

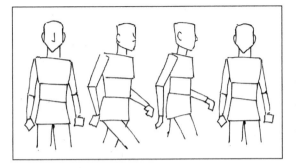

The farther you turn the body toward a profile view, the narrower it gets. To delineate the chest, shift the first rectangle a little to the front. To show the buttocks, shift the third one. For a rear view, use the same outline as for the front view.

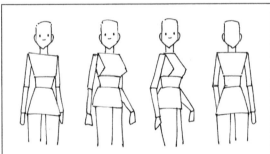

Use little strokes to indicate the collarbones, the fold at the elbow, and the belly button. If the character is shown from the rear, the lines of the shoulder blades, the spine, the elbows, the buttocks...

For a woman's body, proceed in the same way, but make the chest more pointed and the buttocks more prominent. Have you drawn the basic view correctly? Now round out the chest, stomach, the angle of the shoulders, the beginning of the armpits, the arch of the back and the curvature of the buttocks...

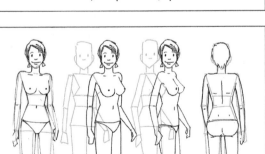

For a woman, draw round breasts, a thinner waist, and slightly wider hips.

# Clothing

In addition to the posture and facial expression of your characters, the clothes that you choose for them will also help to define their personality.

A low-cut dress or a leather jacket, a T-shirt or a button-up shirt, a loosened tie or a shirt with buttons undone—these are all details that add personality to your characters.

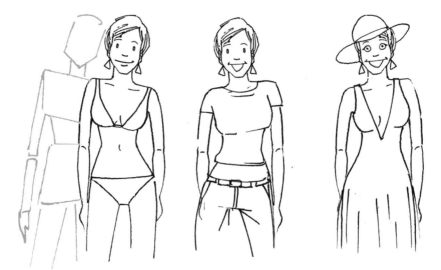

In order to draw tight-fitting clothes (a T-shirt, a close-fitting blouse, jeans), conform them closely to the body shapes already covered. Add a few folds at the armpits, elbows, and crotch.

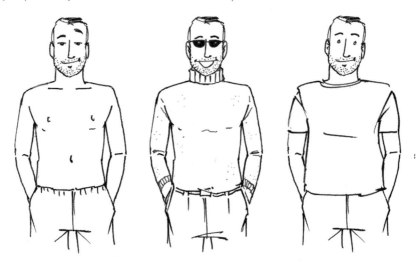

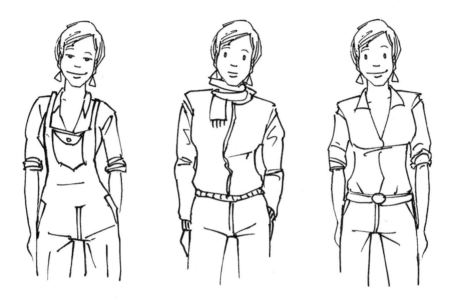

For looser-fitting clothes (a jacket, a blouse, a suit), add some fullness or curves.
Draw the folds more emphatically.

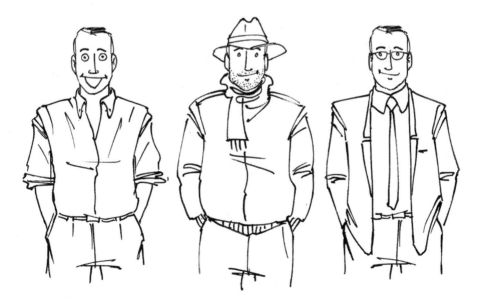

# Busts

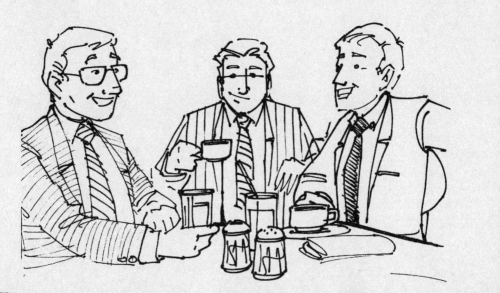

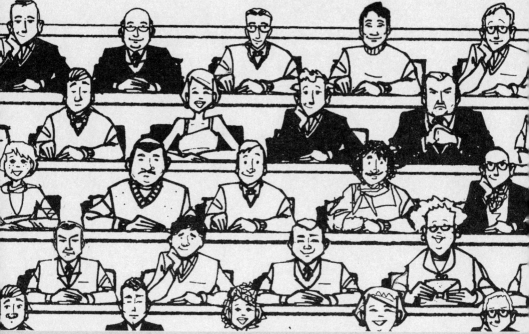

# The Human Body

## Getting Started

If we look at it schematically, an adult's head is between 1/7th and 1/8th of the overall height of the body. The legs take up half of the overall height of the body.

A child's head is proportionally larger than that of an adult and can take up as much as a quarter of the overall height of the body.

It is up to you to choose which of these characteristics to make more or less prominent in order to achieve the desired age and size of the character. Play with the proportions, in terms of both height and width, in order to create a character that is chubby, short, thin, stocky…

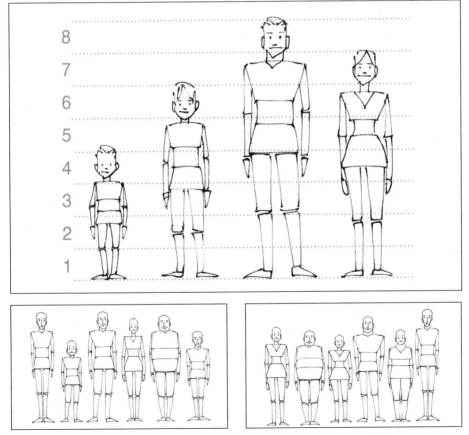

The proportions of the human body vary according to each person's age, gender, and shape.

Whatever the character you are about to draw, first quickly sketch the different parts of the body, starting with the head and then moving down to the torso and the legs, in order to get a sense of the character's proportions and the space it is going to take up on the page.

As you did with the bust portraits, start by taking up the pose you want to draw and observe the movement of your arms, your shoulders, your legs…Now assemble the various geometric shapes before you delve into the details.

Even if the character is standing still and not moving, do not hesitate to offset certain elements: move the head a little off-center, draw one shoulder a little higher than the other, create a little sway in the pelvis, separate the feet…in order to produce a natural, spontaneous posture.

When the basic sketch has the right proportions and posture, then you can fine-tune the details.

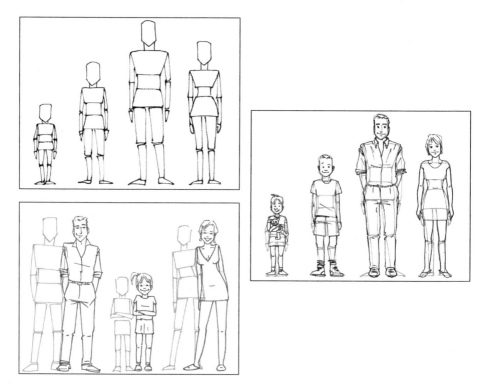

## Point of View

- **Low-angle view (view from below).** Create an upward perspective, with the head becoming smaller and the feet larger.

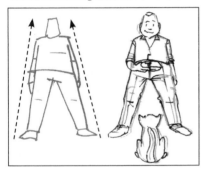
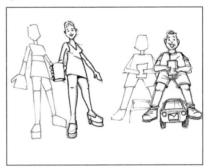

- **Bird's-eye view (view from above).** Do the opposite: make the face larger and the feet smaller.

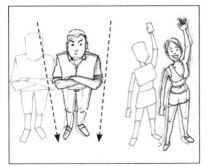
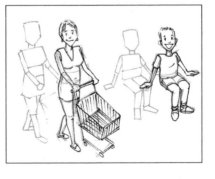

## Body Movements

As you did with the bust portraits, take up the pose that you want to draw and observe the movement of your arms, your shoulders, your legs…

Assemble the various geometric forms you need in order to create the character's position.

When the proportions seem right, add and tweak the details.

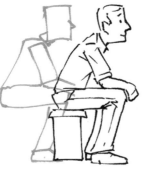

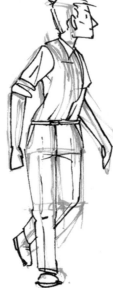
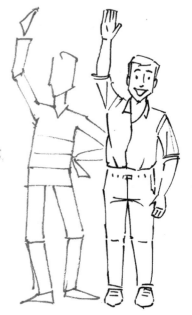

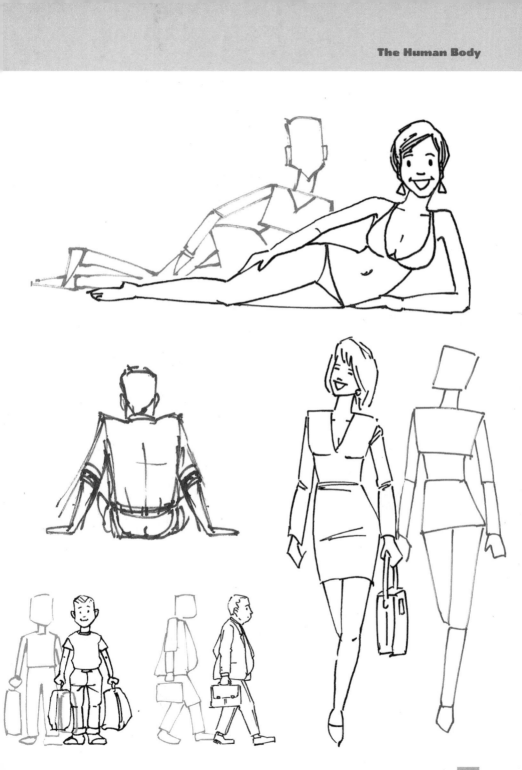

# Athletic Bodies

For bigger movements, like jumping, running, or dancing, don't be afraid to exaggerate, emphasizing the body's twists and shifts, head movements, and elongations of the arms and legs.

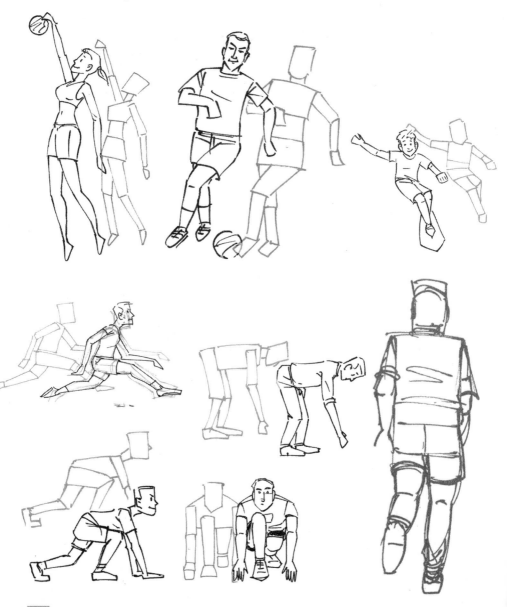

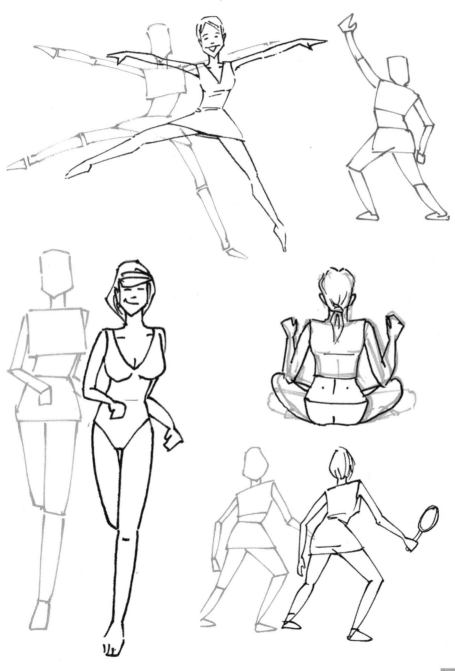

# At Rest

Even when it is static, a person's posture expresses their temperament or their mood. A little shift, a head buried in their shoulders, their arms crossed—these are all details that can be combined with the facial expression to evoke relaxation, nonchalance, distrust, etc.

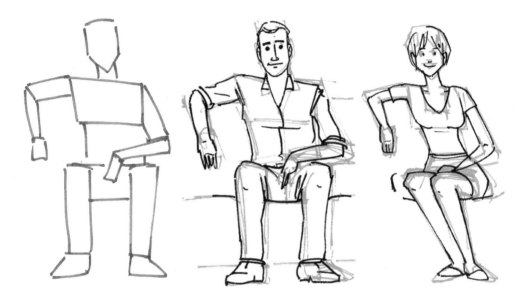

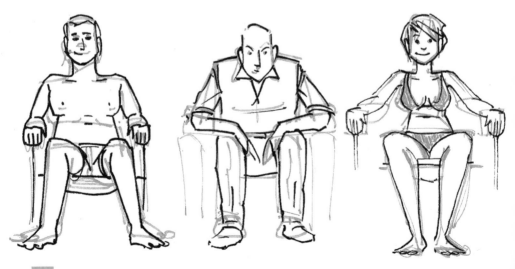

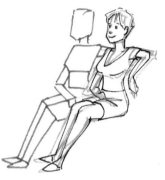

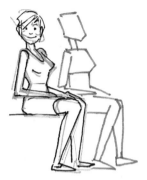

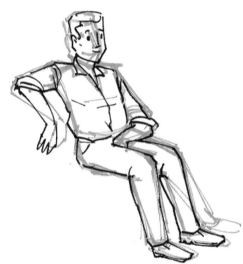

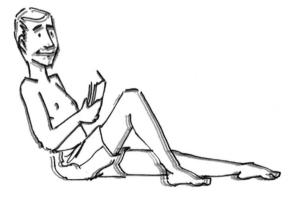

# Silhouettes

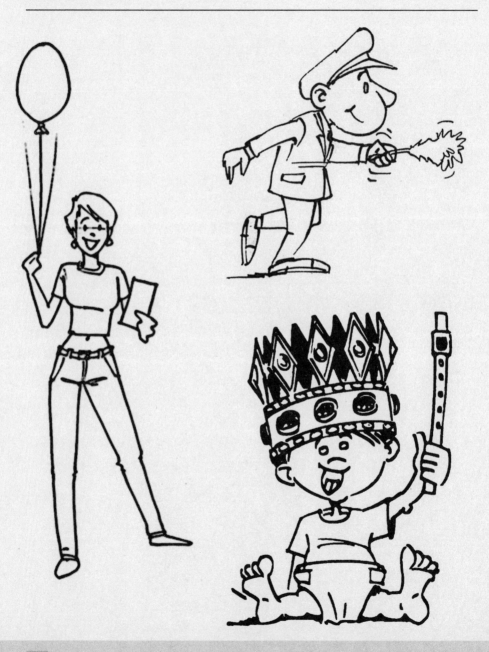

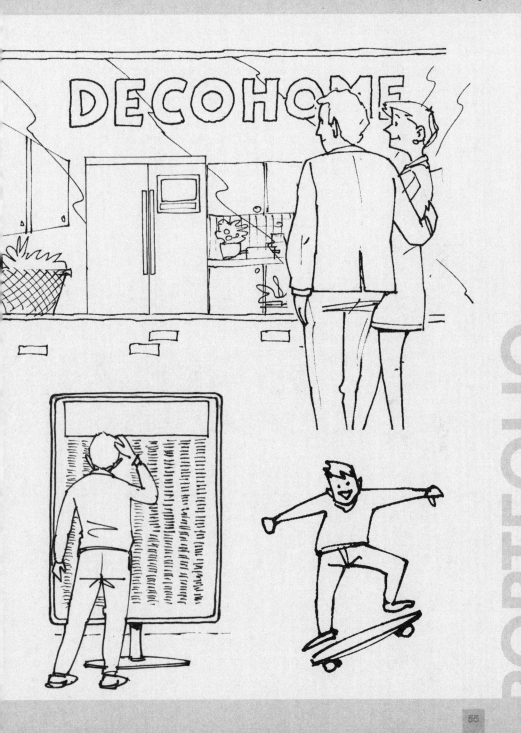

# Types and Stereotypes

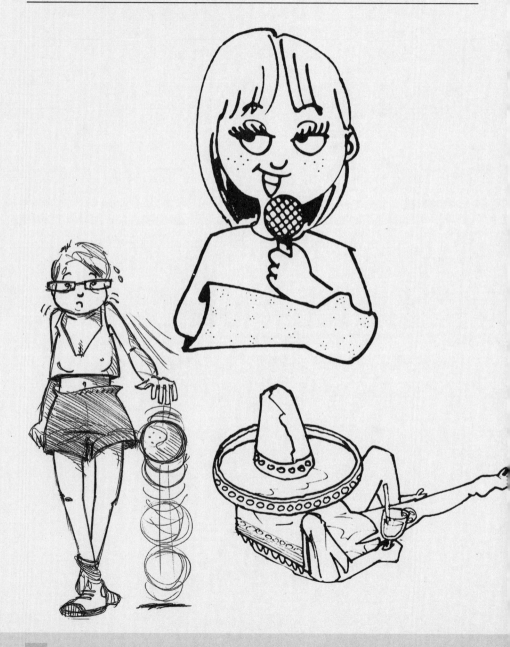

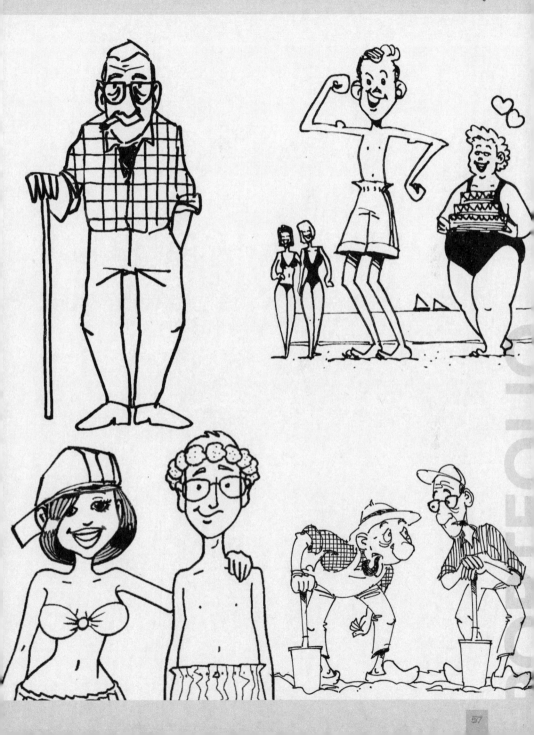

# Feet

Looked at schematically, the foot is made up of three squares: one for the heel, one for the midfoot, and one for the toes.

In order to draw a bare foot, round out the heel, the sole, and the instep. Use a small, curved line to indicate the anklebone. Whether from the side or from the front, the toes can be represented by five rectangles of different sizes.

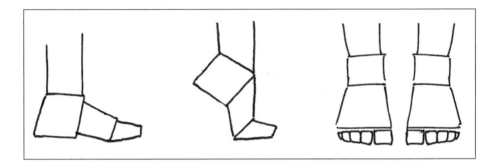

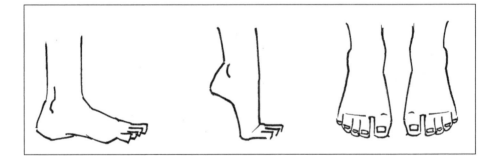

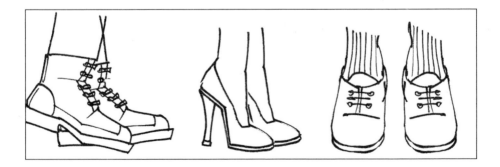

# Hands

Note that the hand fits into two squares: one for the palm, and one for the fingers. Each finger in turn is made up of three rectangles, while the thumb is made up of two. The wrist is slightly narrower than the hand.

In order to create variations, all you have to do is shift the rectangles that make up the fingers and change the shape of the square making up the palm.

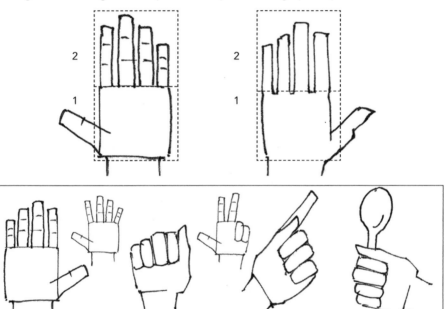

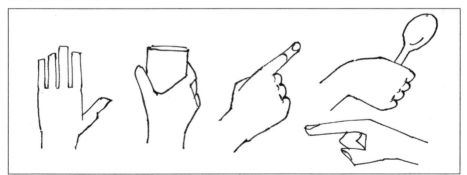

Hands from the front.

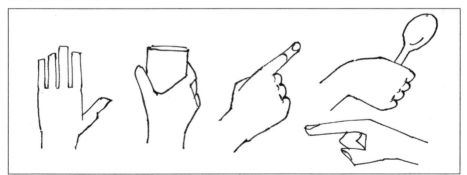

Hands from the back.

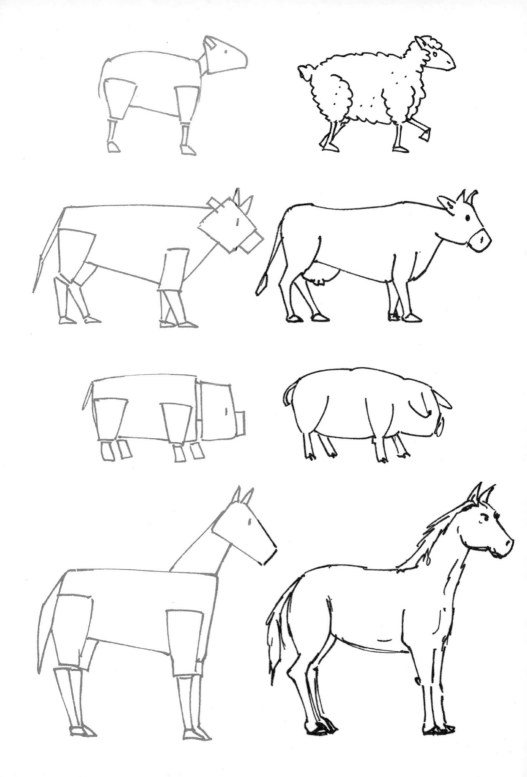

# Animals

## Getting Started

Just like the human body, the bodies of most animals can be broken down into simple shapes.

As a generalization, small rodents have fairly stocky bodies and triangular heads. Carnivores tend to have a thinner body and a squarer head. As for ruminants, they have variable proportions: you will have to look at them carefully before putting pencil to paper.

Of course, we will not be able to show roughs of every kind of animal on the planet here! These first basic drawings should provide a foundation that allows you to imagine and draw other animal species.

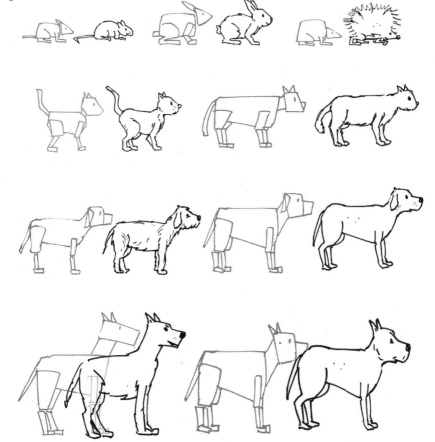

## Animals At Rest

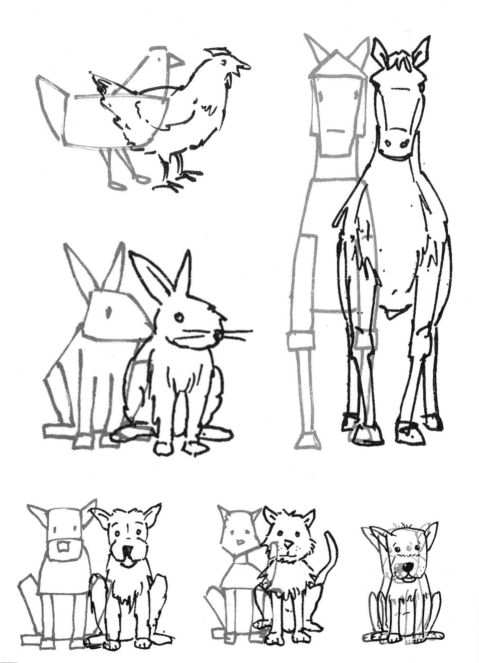

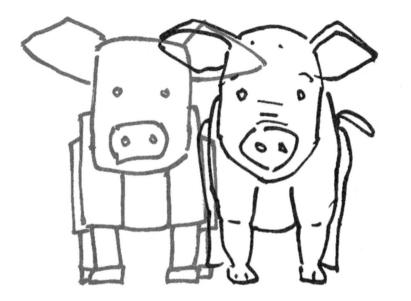

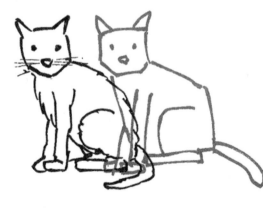

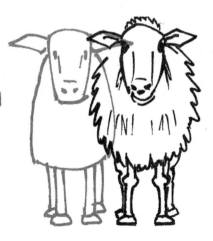

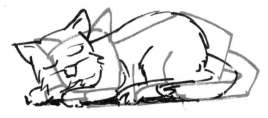

## Animals in Motion

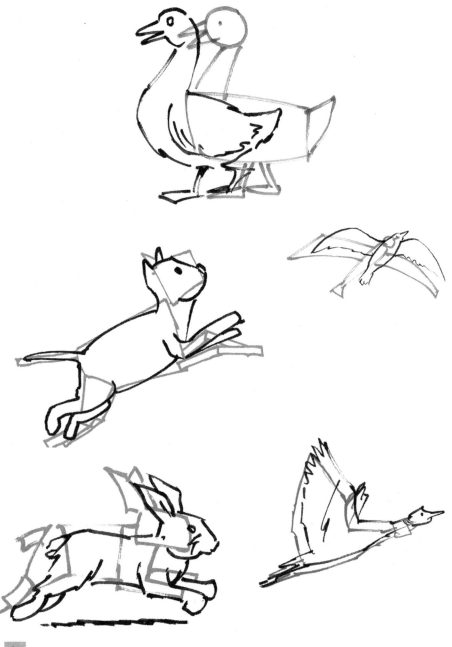

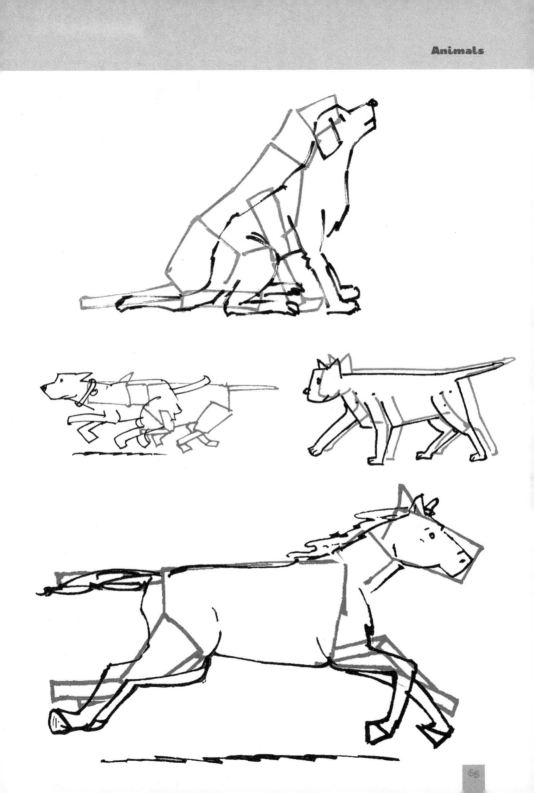

## Sea Animals

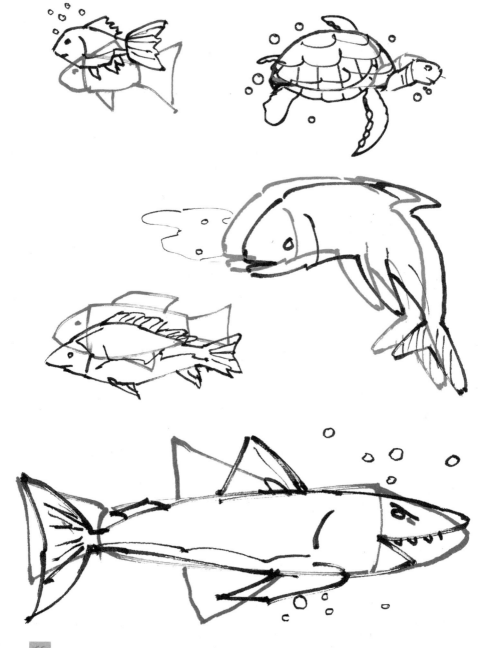

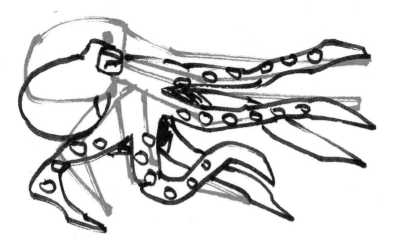

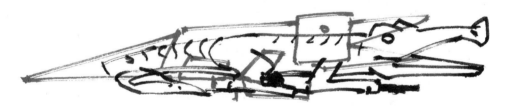

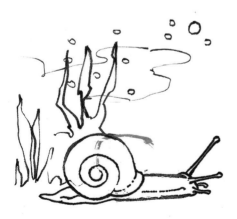

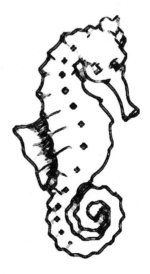

# Exotic Animals

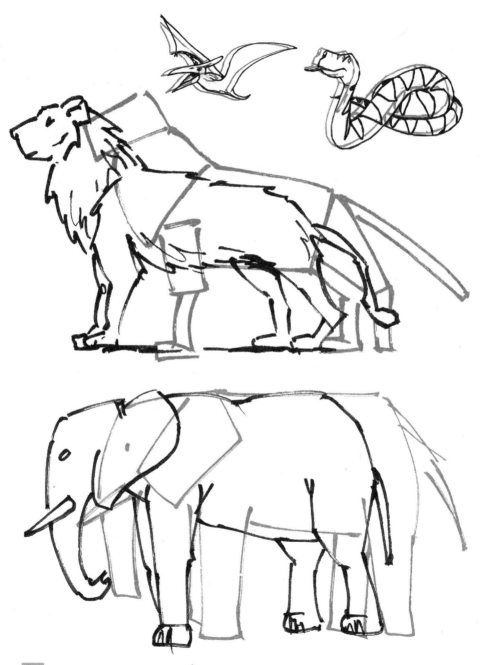

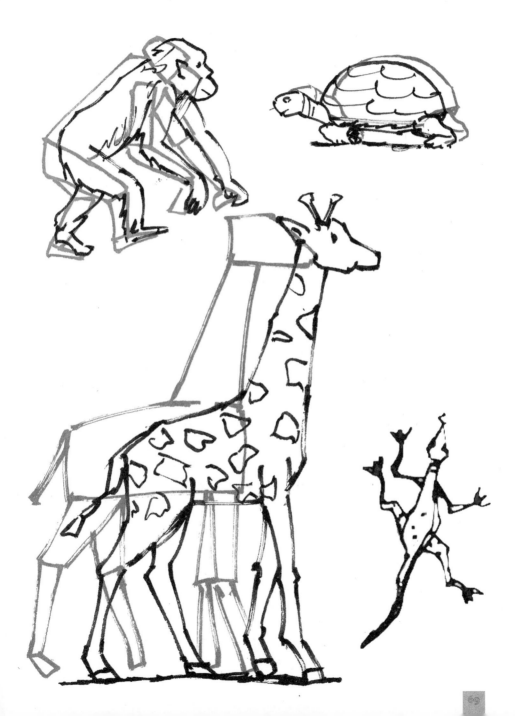

# The Life of Animals

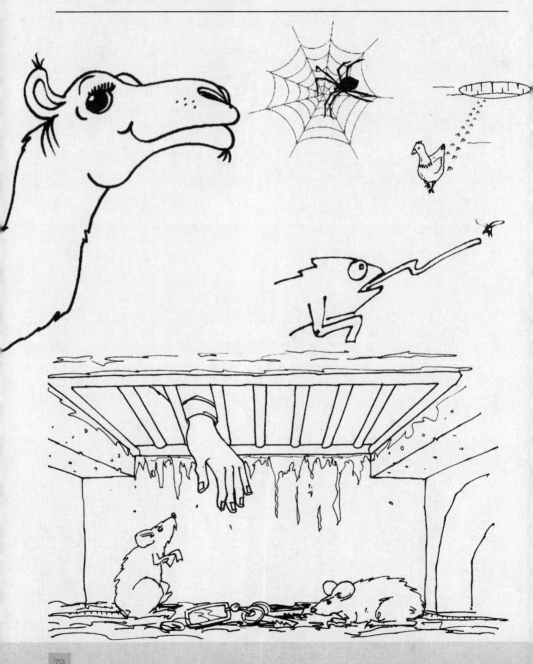

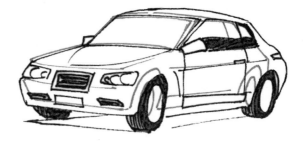

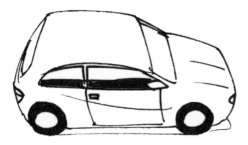

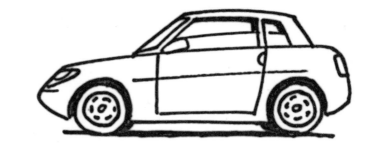

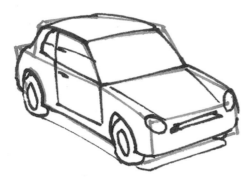

# Cars

## Getting Started

Seen from the side, all four-wheeled vehicles can be schematically drawn as two rectangles on top of each other. Of course, their proportional lengths may vary depending on the kind of car (for instance, on whether it is a sedan or a minivan), but keep in mind that the vehicle's body always makes up approximately two thirds of its total height.

**1.** First sketch the angles and general shape of your vehicle.

**2.** Adjust the proportions if necessary.

**3.** Add the details that will contribute to defining its personality, then make your final drawing in ink.

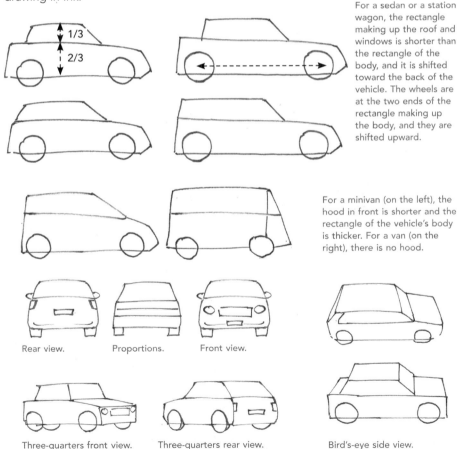

For a sedan or a station wagon, the rectangle making up the roof and windows is shorter than the rectangle of the body, and it is shifted toward the back of the vehicle. The wheels are at the two ends of the rectangle making up the body, and they are shifted upward.

For a minivan (on the left), the hood in front is shorter and the rectangle of the vehicle's body is thicker. For a van (on the right), there is no hood.

Rear view.     Proportions.     Front view.

Three-quarters front view.     Three-quarters rear view.     Bird's-eye side view.

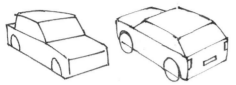

Three-quarters rear and front view from above.

Front view.

View from above.

Three-quarters view.

Starting with the very first sketch, stretch the wheels into ovals depending on the angle from which you are drawing the vehicle.

# Details

A sloping windshield, a hood angled downward, triangular headlights, curved lines on the vehicle's body, or a few reflections in the window can all make your drawing look more realistic.

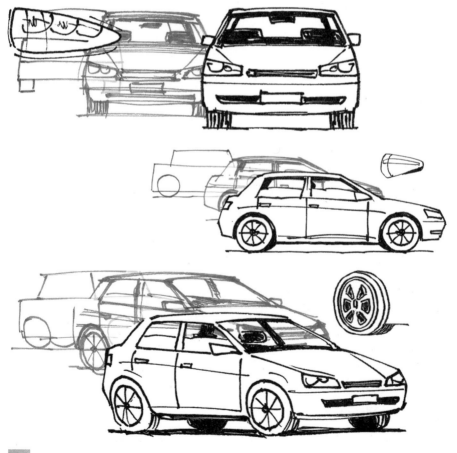

# Other Vehicles

By starting with the basics of a standard modern car and changing the proportions, you can draw any number of other vehicles. Of the multitude of existing models, here are a few that will allow you to draw others as well, if you look, observe, and imagine.

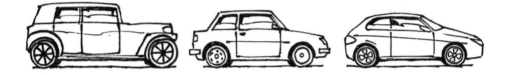

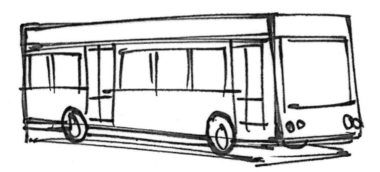

## Vehicles and Drivers

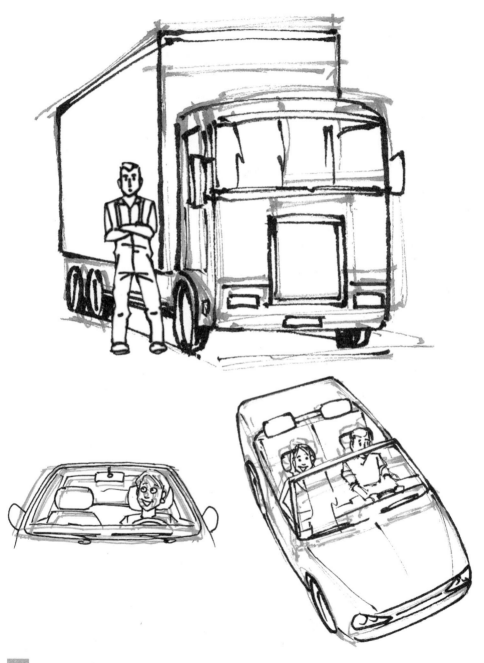

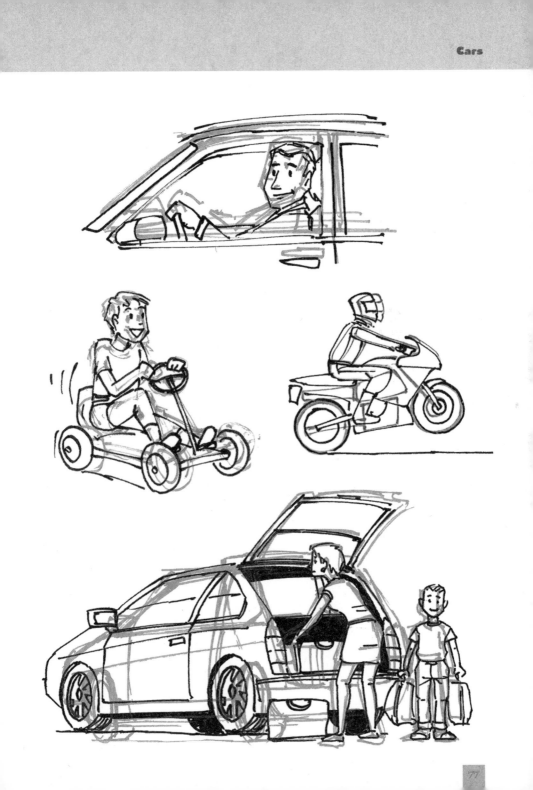

# Sample Figures

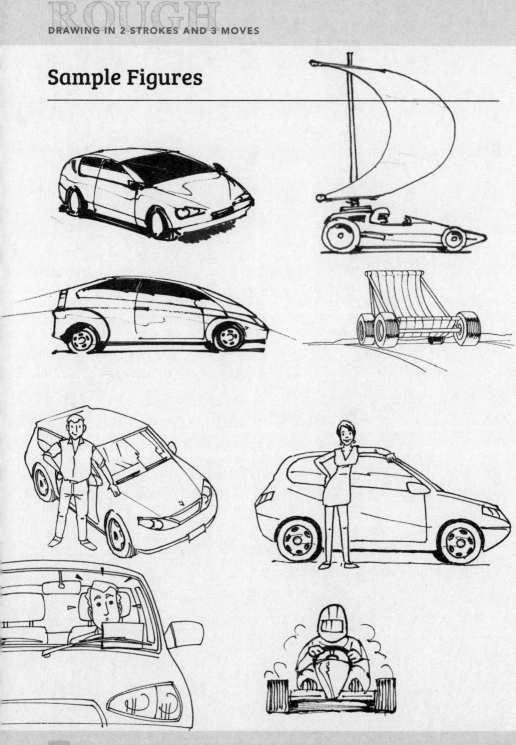

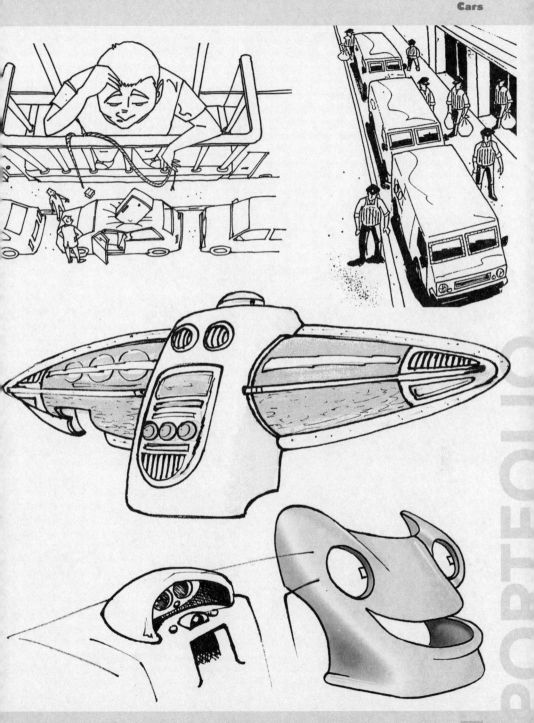

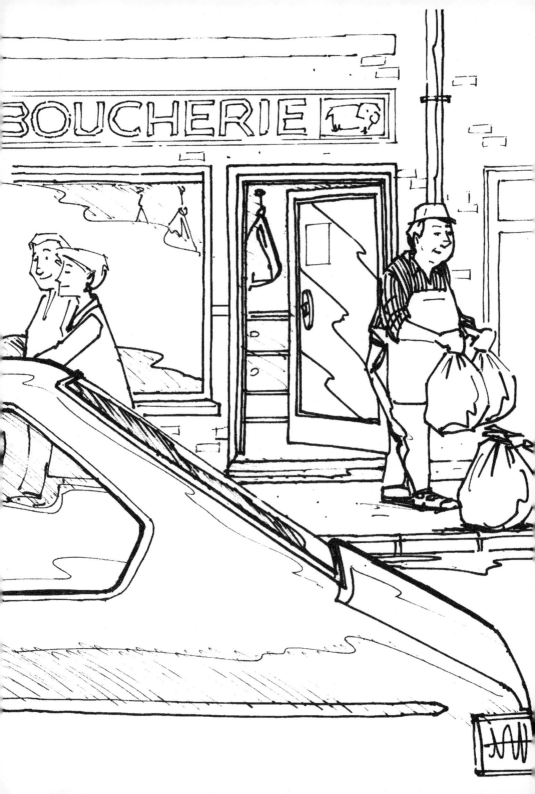

# Outdoor Scenes

## Getting Started

To create a rough of an outdoor scene, you have to start by setting up a frame and a format.

**1.** With a felt pen, sketch the format (the outer frame) of your drawing, freehand, on the page.

**2.** Now, within this frame, sketch the horizon line.

**3.** Now sketch the characters.

**4.** Position the buildings and other elements of your scene.

### Horizon Line

When you take a photograph standing on a beach or in the desert, the horizon line is approximately in the lower third of the picture. Starting with this horizon line, with just a few strokes you can evoke a sunset over a beach, a walk in the desert or across the ice...Of course, if you are looking down at the street from the 15th floor of a building (in a bird's-eye view) or if you are looking up at a hang glider going past in the sky (a view from below), you will not be dealing with the horizon line. But most of the time, the horizon line will serve as your reference point in imagining your landscape.

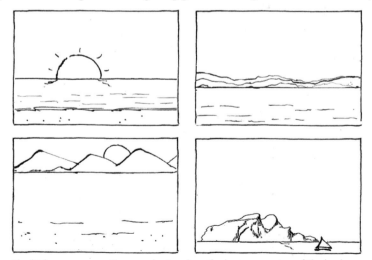

The higher up you position your horizon line, the lower your view of the landscape. The lower down you place the line, the more of an aerial view you will achieve.

## Vegetation

You have sketched the frame and the horizon line. Most of the time, this line will be hidden by vegetation or buildings.

But where are you going to take us? Into the desert, into the mountains, into the forest? Will there be people in this scene? Will they be alone, will there be a pair of lovers, a group of friends?

Here are some basic sketches with which to draw a fir tree, an oak, a birch tree, or else a bush, a hedge, or a field...All you have to do to create a landscape is choose which ones to put together.

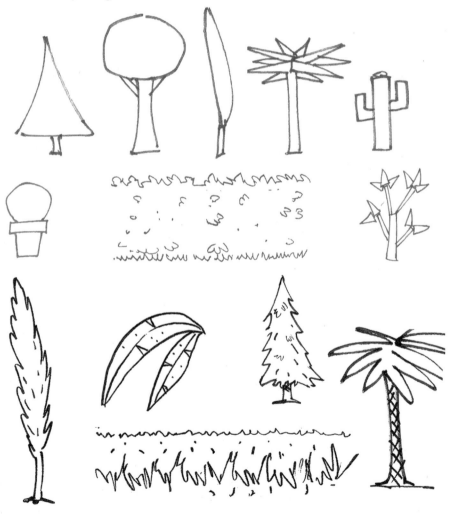

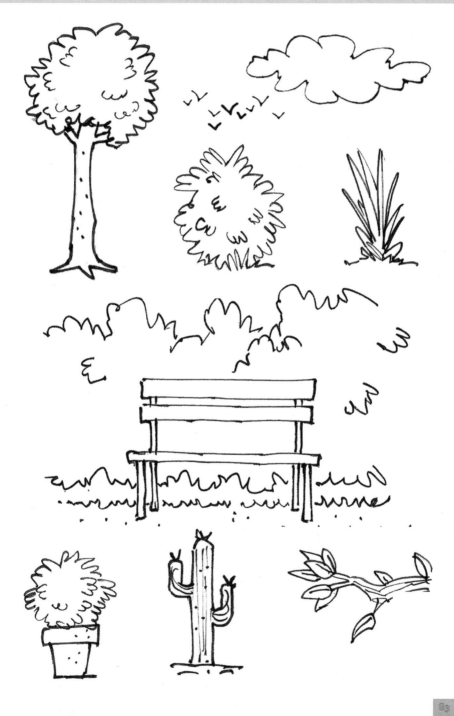

# Natural Landscapes

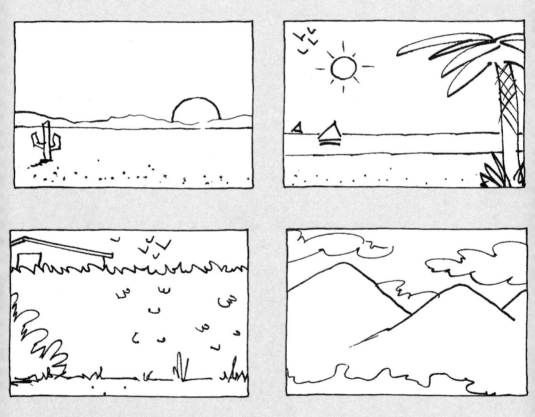

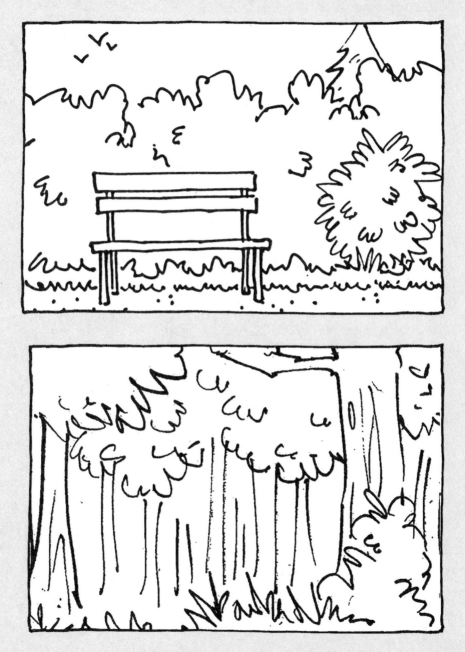

## Some Buildings...

Without going into complicated architectural details, we have all the elements in our heads that we need in order to quickly be able to identify the style of a building. Two rectangles on top of each other, a door, a window, a chimney, and you see a house. A pointed roof, some carriage gates, and there's a farm. Two towers on either side of a building, and here we have a castle.

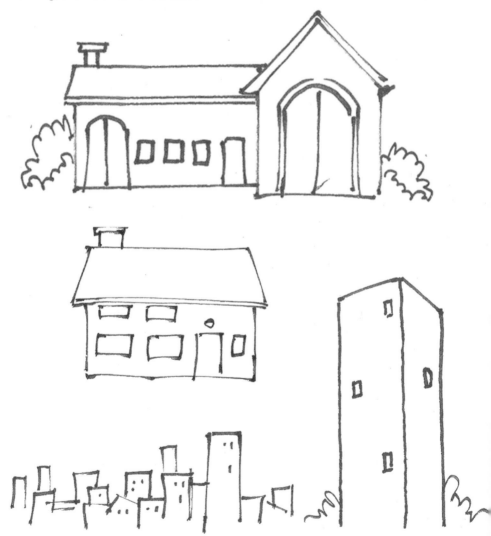

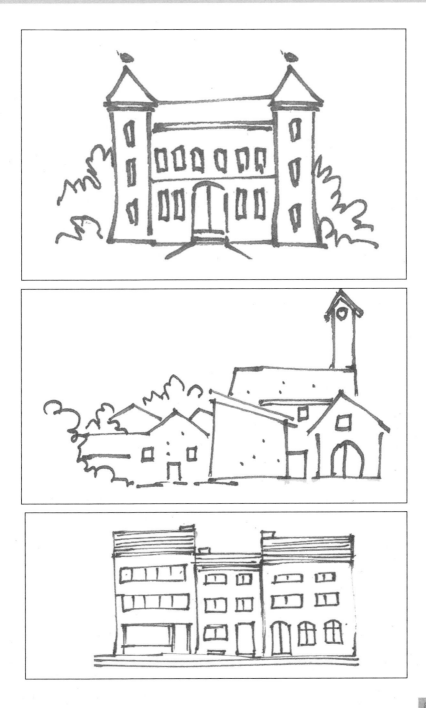

In any case, fine-tune the building to an extent that reflects the importance you want it to have in the landscape. Here, the architectural details are more developed.

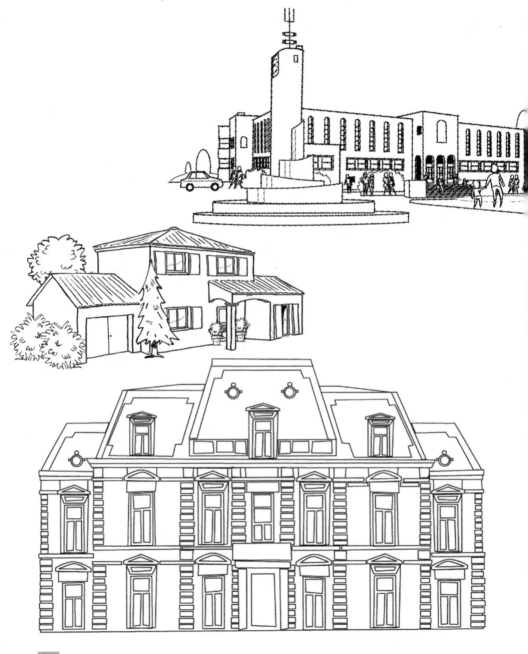

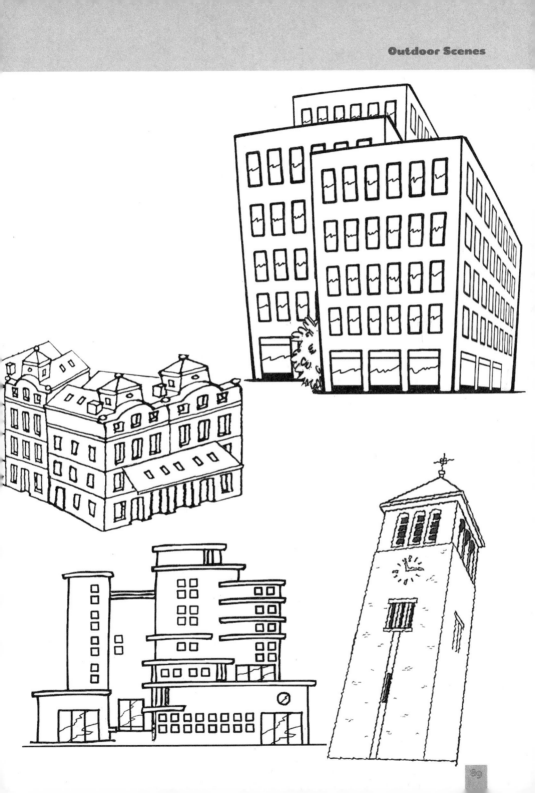

## ...And Their Backdrops

Just as with a landscape, a few lines are usually enough to suggest the background: the forecourt of a church, a suburban house, a boulevard, or a village square.

It's up to you to define the level of detail necessary for your landscape to be understood as needed.

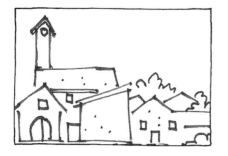
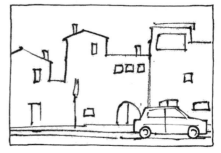

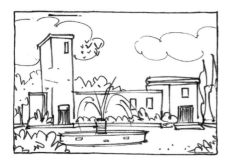
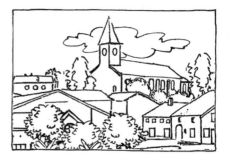

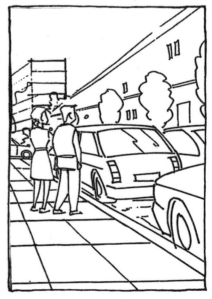

# Nature and People

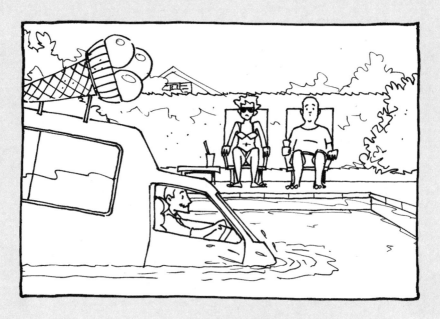

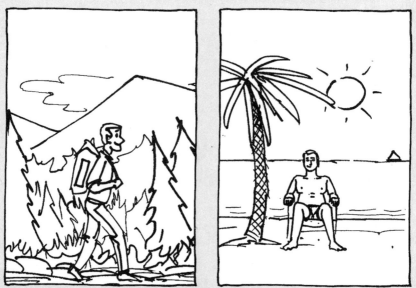

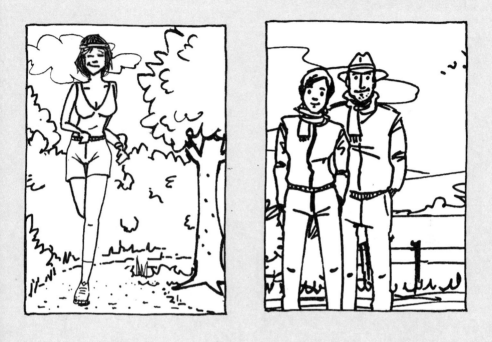

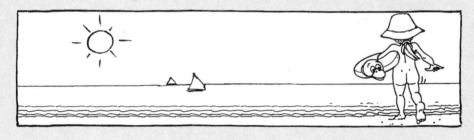

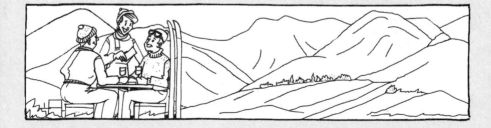

PORTFOLIO

# Outside

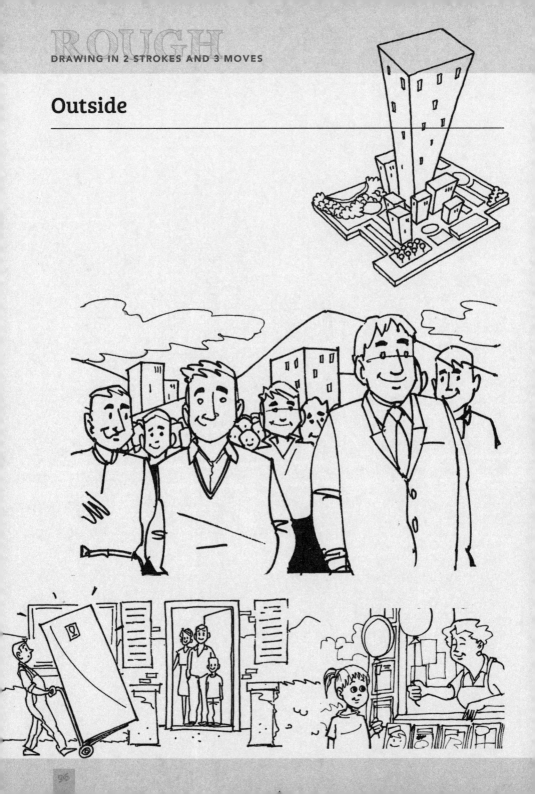

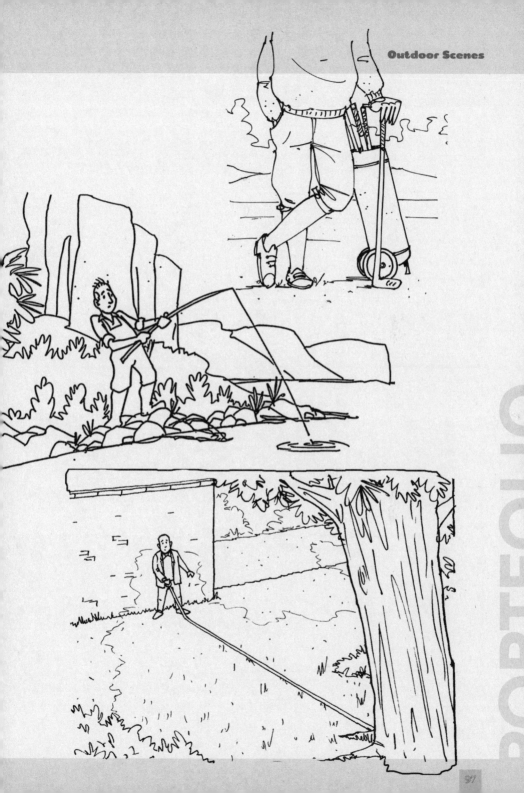

## Roads and Pathways

In order to create an entire world with just a few strokes of your pencil, all you have to do is sketch a narrowing road in perspective, either straight or winding, then add a little vegetation, with a hill or a mountain in the background, a city or a village on the horizon, a car arriving or a truck leaving, a stroll along a boulevard, or a broken-down car.

But in order to quickly create a road, let us return to the horizon line, which is the basis for the establishment of perspective.

**1.** First position the vanishing point at the center of the horizon line.

**2.** Then draw a central line and two lines, one on either side, that converge toward the vanishing point.

**3.** Then add two more lines to represent a hill. You now have the fundamentals of your road.

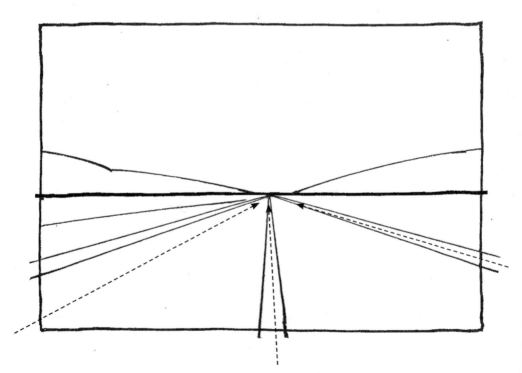

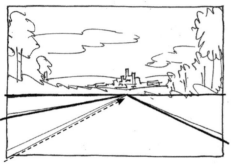

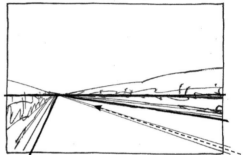

In order to change the viewing angle, you can just play around with the horizon line and the vanishing lines. Thus, if you move the vanishing point to the right and the center line to the left, you will be traveling with the traffic...

...and, if you move the vanishing point to the left and the center line to the right, you will be moving against the traffic.

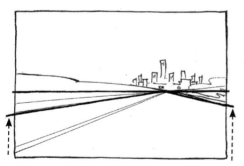

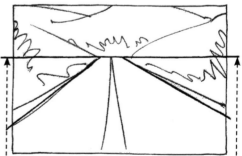

If we raise the two vanishing lines, we will have a more panoramic view and the road will look wider.

The higher the horizon line, the steeper the road seems to be.

# Drawing Your Road

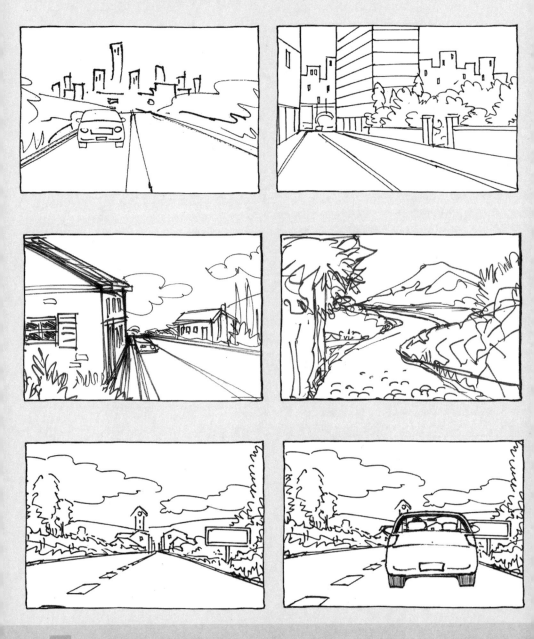

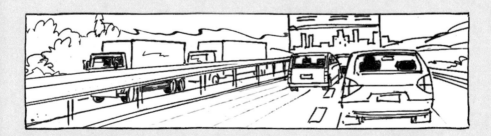

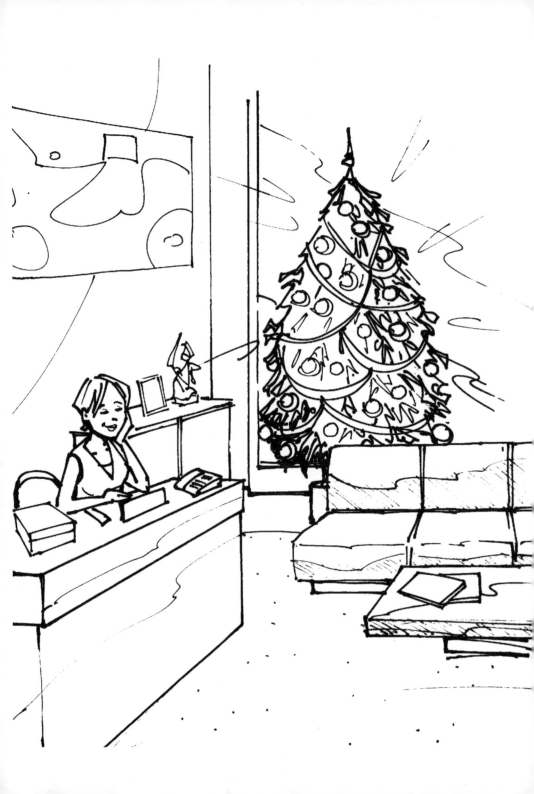

# Indoor Scenes

## Getting Started

Very roughly, we can say that in a traditional house, the height of a door is approximately three quarters of the height of a wall; and the height of an adult is two thirds of the height of that wall.

Of course, these proportions will not be the same in a church, a supermarket, or a train station, but they should allow you to start drawing your first living spaces.

Stand against a wall and look at the opposite wall. This wall can be roughly represented as a rectangle, centered within your frame.

If you then draw perspective lines leading to each of the four corners of the frame, you can indicate the side walls, the floor, and the ceiling. To change the viewing angle, modify the beginning rectangle and the perspective lines.

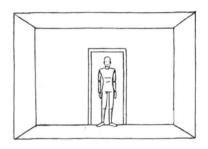

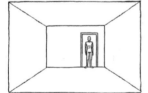
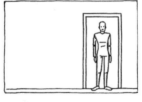

The smaller the rectangle, the deeper the room will seem to be (see left). As you get closer and closer to the wall (on the right), the rectangle disappears.

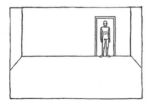
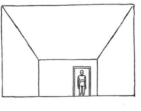

Move the rectangle upward and you will have a view from above (see left). To get a view from below, move the rectangle down (see right).

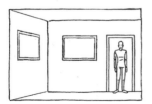
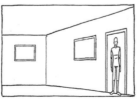

For a side view, shift the original rectangle to the right or the left.

## Furnishings

Very schematically, we can divide furnishings into old and new ones. At first glance, what mainly differentiates these two styles is the complexity or simplicity of their design.

If you want your furnishings to exude a certain level of modernity, draw them using simple geometric forms and clean lines.

The more curves and flourishes you add, the older the furnishings will seem.

Here are some basic elements that will allow you to quickly furnish a living space.

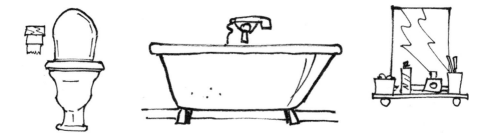

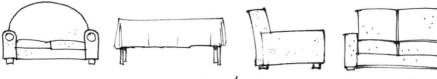

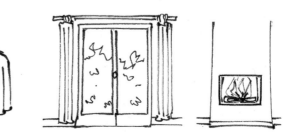

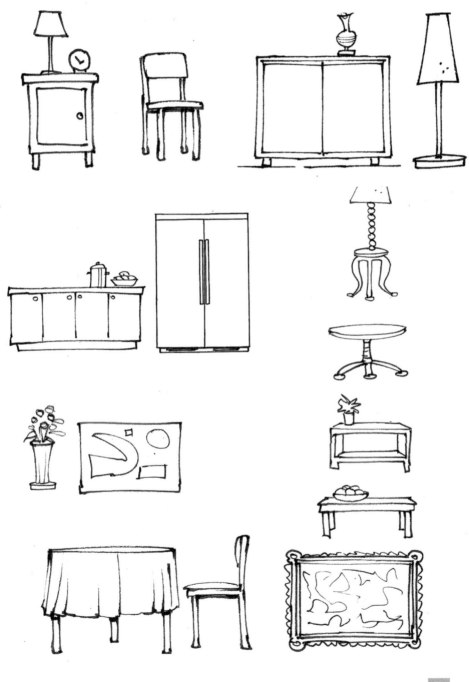

# Interior Decoration

Interior decoration is a matter of taste. It is up to you to decide whether you want to create your grandparents' living room or your next-door neighbor's; a friend's bedroom or your aunt's kitchen.

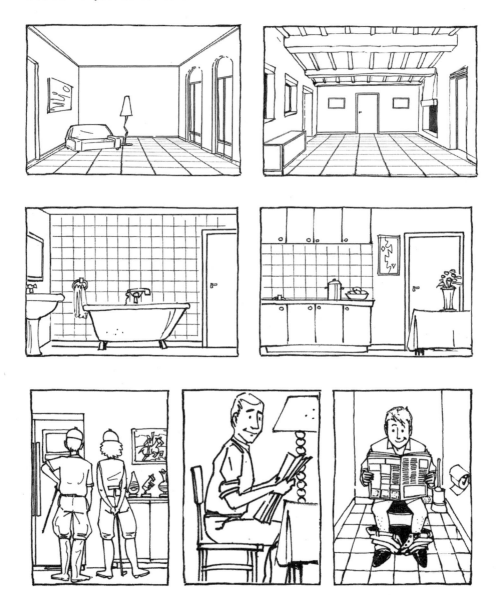

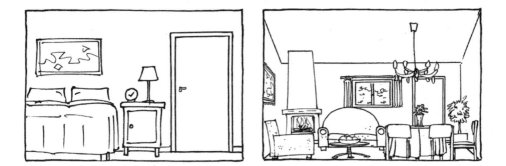

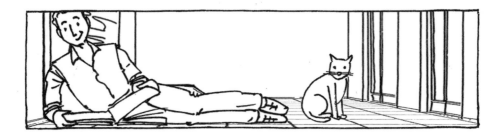

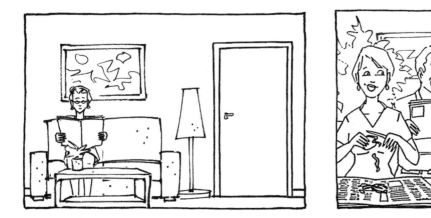

# Some Interiors

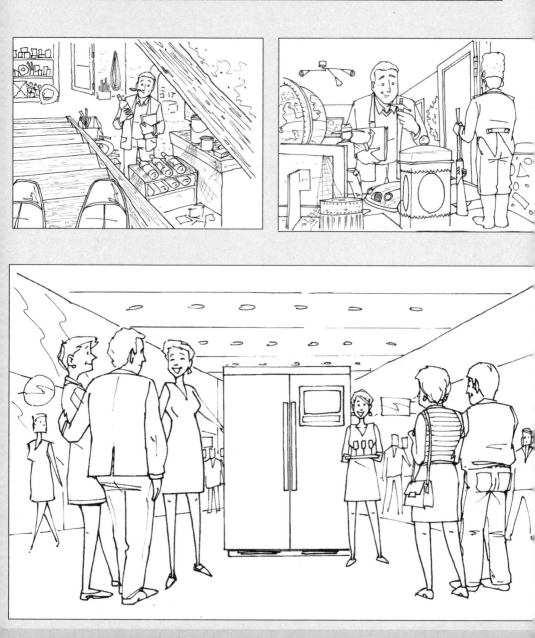

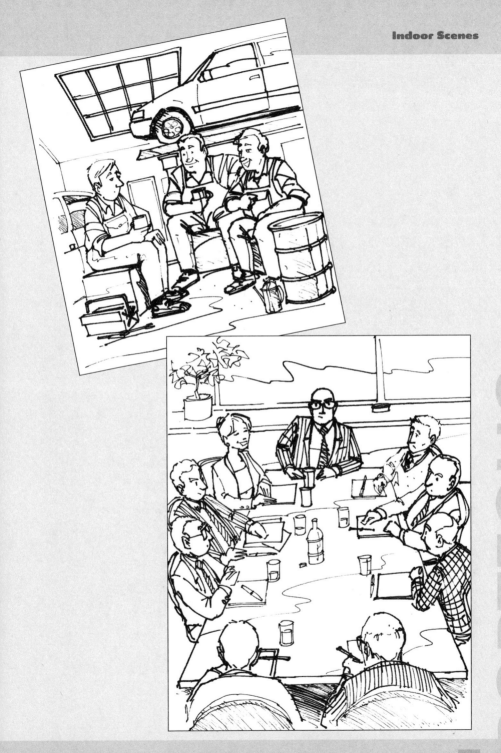

PORTFOLIO

# More Rocky Nook Titles

These books will help you learn techniques for drawing and painting.

And many more titles that you can find at www.rockynook.com